MAY – 2 2018

WITHDRAWN

Impressionists

D1529804

Impressionists

Carol Jacobi

Tate Introductions
Tate Publishing

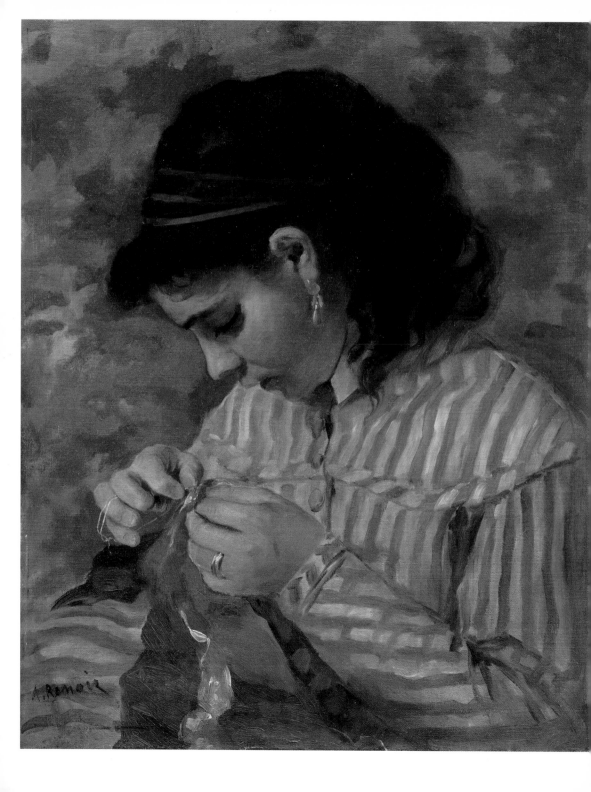

1. Pierre-Auguste Renoir
Lise Sewing 1866
Oil paint on canvas
56.5 × 46.4
Dallas Museum of Art

The First Impression

By the term impression, I mean all our more lively perceptions,
when we hear, or see, or feel, or love or hate or desire or will.
David Hume, 1748[1]

In April 1874, the French daily satirical magazine *Le Charivari* ran
a mocking headline: 'Exhibition of the Impressionists'.[2] The critic,
Louis Leroy, was making fun of a new group calling themselves
the Anonymous Society of Painters, Sculptors and Engravers. The
article described a bewildered exhibition-goer, in front of Camille
Pissarro's *Hoar Frost* 1873 (fig.39), wiping his spectacles, thinking
they are smudged, before exclaiming, 'What on earth is that?'; after a
few more such encounters he loses his reason altogether and leaves
singing 'Hi-ho! I am impression on the march!'[3]

Leroy was satirising an idea that had been of interest across Europe
since the previous century: the fascination with sense impressions.
Claude Monet had included an on-the-spot study in the exhibition
and called it *Impression, Sunrise* 1872 (fig.34) and a more sympathetic
critic, Jules Castagnary, explained, 'they are impressionists in the
sense that they render not the landscapes but their sensation of the
landscape.'[4] By 1877, the group had adopted the name, which is now,
of course, world-renowned.

The Anonymous Society exhibition was challenging the status
quo of the official annual Salon, selected and staged by the Parisian
Académie des Beaux-Arts. Between 15 April and 15 May, thirty
artists showed 165 works in the modern iron-and-glass studio of the
leading photographer, Gaspard-Félix Tournachon, aka 'Nadar', on the
busy boulevard des Capucines (fig.3). They were middle-class men
and women, impatient with old-fashioned, academic conventions
that required artists to aspire to literary and historical subjects and
idealised classical figures. They were after a more authentic art,

relevant to their own times and experiences. Seven more exhibitions followed – in 1876, 1877, 1879, 1880, 1881, 1882 and, finally, 1886, when the group broke up.

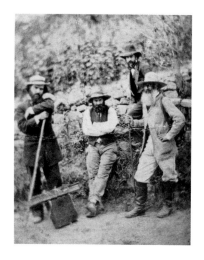

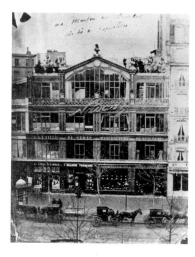

2. Paul Cézanne with Camille Pissarro on a painting trip, France c.1875
Albumen print
9.1 × 5.5
Pissarro Family Gift
Ashmolean Museum, University of Oxford

3. Nadar
Studio of Nadar at 35 boulevard des Capucines, Paris 1860
Private collection

4. Franz Benque
Claude Monet 1880
Bibliothèque Nationale de France, Paris

5. Edgar Degas c.1860
Bibliothèque Nationale de France, Paris

6. Charles Reutlinger
Berthe Morisot 1875
Musée Marmottan Monet, Paris

7. Pierre-Auguste Renoir 1875
Musée d'Orsay, Paris

8. Alfred Sisley 1880
Archives Durand-Ruel

9. Charles Gleyre
The Bath 1868
Oil paint on canvas
88.9 × 63.5
Chrysler Museum of Art,
Virginia

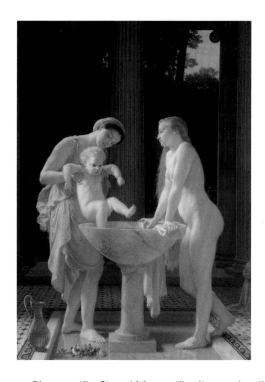

Pissarro (fig.2) and Monet (fig.4) were leading figures, with Edgar Degas (fig.5), Berthe Morisot (fig.6), Pierre-Auguste Renoir (fig.7) and Alfred Sisley (fig.8) among the other members. Monet met Pissarro when he first arrived in Paris in 1859, and came across Renoir, Sisley and Frédéric Bazille (1841–70), when they were fellow students of the academic master Charles Gleyre. They were tutored in the ideals of classical antiquity (fig.9), but drawn to contemporary genre, landscape and still life, forms that the Academy rated inferior. They fell in with a group of radical writers and artists who were championing realism and who associated in the cafés of Montmartre, particularly the lively Café Guerbois. There they met Degas and older artists, including Gustave Courbet and Édouard Manet, who were battling the Academy from within.

Gleyre's studio closed in 1864 and the companions painted in the countryside, studios and lodgings. Instead of professional models and props, they represented relatives, friends, and people and things that they could observe in everyday life. Models were expensive, and Monet and Renoir, in particular, were often short of funds.

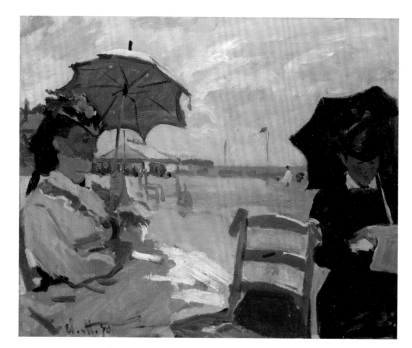

10. Claude Monet
The Beach at Trouville 1870
Oil paint on canvas
38 × 46.5
The National Gallery,
London

Together with Sisley, they shared Bazille's workspace, where Renoir painted him in 1867 (fig.24). The picture is a kind of manifesto of the group's conception of the modern artist. Renoir departed from the tradition of posed studio portraits to show Bazille as if caught unaware, informally dressed in smock and slippers, absorbed in his work; he and Sisley (out of sight), were engaged in painting still lifes from birds on a white cloth (both of which pictures are now in the Musée Fabre, Montpellier), a subject favoured by the Dutch painters that the young artists admired. In the background, we see a clutter of canvases and, on the wall, the corner of a landscape painted in the forest surrounding Barbizon – the centre for the Barbizon school, which had pioneered naturalistic approaches to nature from the 1830s. Encouraged by Pissarro (who had worked with the Barbizon group himself), the young painters took inspiration from these, earlier artists. Barbizon compositions were relatively picturesque, however, and next to this painting, is Monet's recent, more boldly composed and coloured work, *Road to Saint Siméon Farm in Winter* (1867, private collection).

11. Edgar Degas
Beach Scene 1869–70
Oil paint on paper on
canvas
47.5 × 82.9
The National Gallery,
London

A significant figure among the older generation of landscape painters was Eugène Boudin (1824–98), whom Monet had met as a teenager in his home town of Le Havre. Boudin encouraged Monet to take art seriously and to paint directly from nature, in the open, and seize 'the first impression'.[5] He preferred the variety of plein-air effects to the conventional illumination of the studio, where landscapes were lit according to picturesque conventions and objects by light and shadow cast from a single window. Monet owned *Beach Scene, Trouville* (fig.22), painted by Boudin in the 1860s, which captures, in swift strokes, fashionable men and women huddled on the beach under a blustery sky. Boudin exhibited in the impressionist exhibition but never considered himself an impressionist.

In the summer of 1870, Monet, his new wife Camille and their son Jean, joined Boudin at Trouville-sur-Mer in Normandy. There, Monet made five plein-air oil sketches at the same location, including *The Beach at Trouville* (fig.10). The woman on the left is Camille, and her companion is probably Marie-Anne, the wife of Boudin. A sandy fingerprint in the light area above the red cushion confirms that the work was painted in situ, as do the dashing strokes, summarising

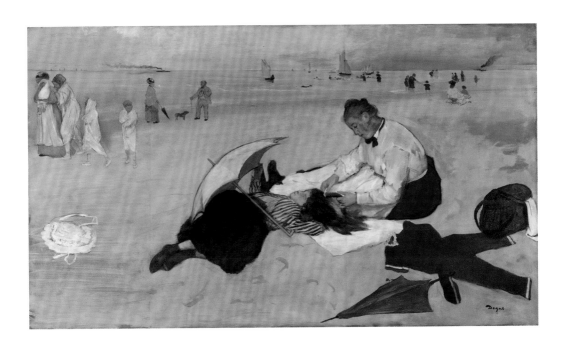

light glancing off the wind-ruffled skirt and the floral hat dulled by the shade of the parasol. Again, Monet's composition is more adventurous than his mentor's; the figures are shown close-up, off-centre, cut off at the edge of the canvas, and almost silhouetted against the bright sky, as though glimpsed with a turn of the head.

By contrast, Edgar Degas's *Beach Scene* (fig.11), created sometime around 1870, was painted in the artist's studio. Degas was of more comfortable means. He, too, had stayed in Normandy, but observed his figures in the more traditional, academic way, from models posed for the purpose, and other details from sketched or remembered impressions. There is nothing academic about the result, however. As with Monet's painting, ordinary appearance and informal gestures retain the freshness and texture of everyday experience, far from the smooth and artificial look of establishment painting.

Neither Monet's nor Degas's beach paintings were intended for exhibition; they were studies for more finished pictures that were never completed. The impressionist quality of sketches was increasingly appreciated for its own sake, however. As we have seen, Monet included a sketch of Le Havre, *Impression, Sunrise*, in the first impressionist exhibition, and Degas exhibited his *Beach Scene* in the third.

La Modernité

for the passionate spectator, it is an immense joy to set up house in the heart of the multitude, amid the ebb and flow of movement, in the midst of the fugitive and the infinite. *Charles Baudelaire, 1863*[6]

The painters we now know as impressionists never had a manifesto, but they shared circumstances, networks and ideas. They were part of the new urban middle class, which expanded with the growth of towns, technology and trade in the nineteenth century. Renoir's parents were artisans and apprenticed him to a porcelain factory, while Monet's, a little more well-to-do, hoped he would join their grocery business in Le Havre; Sisley trained to become a successful merchant, like his father, and Degas studied to be a lawyer. Their families objected when they turned to art instead, but the growing towns and cities provided opportunities for young artists to become more independent and paint for new markets and audiences.

Manet and Courbet provided precedents. In 1863, Manet held a solo show at the Galerie Martinet. One of the works exhibited was *Music in the Tuileries Gardens* 1862 (fig.23), which he had painted the previous year. The painting was inspired by a seventeenth-century picture by a follower of Diego Velázquez, held in the Musée du Louvre: Juan Bautista Martínez del Mazo's *Gathering of Thirteen Gentlemen* (c.1640–50). Manet and his circle admired the Spanish school of this period for its naturalism, and his own painting updated the subject to his own time. The figures are modern Parisians and the setting is close to the Louvre, in the public Jardin des Tuileries; instead of classical architecture, the composition is structured by the young trees. The crowd assembled – to hear an outdoor concert, which took place twice a week – are the artist's friends and family. Such subjects were common in popular prints and illustrations, such as those of Constantin Guys, but were not expected of fine art.

Among the men in their sober bourgeois black coats and top hats are Manet, looking out at us from the left edge of the painting; his brother Eugène; and writers and artists such as Jules Husson ('Champfleury'), next to Manet, and Jacques Offenbach, the composer, leaning against a tree on the other side. In the foreground, decked in blue-ribboned bonnets, sit Valentine Lejosne – a patron and friend of Manet, and Bazille's cousin – with Offenbach's mother, Marianne. Right behind her, in the distance, is Bazille himself. A scattering of empty chairs invites the viewer, and Madame Lejosne includes us with her direct gaze.

A shadowy profile under a top hat directly above Madame Lejosne is that of the poet and critic, Charles Baudelaire. Manet and Baudelaire met regularly in the gardens. In 1863, Baudelaire published a three-part essay entitled *The Painter of Modern Life*. This set out his hopes for a modern art for a modern age, calling for artists to follow the example of Guys and find the poetry and permanence of historic art in contemporary life. He encouraged artists and writers to observe their times in the guise of the flâneur, who 'enters into the crowd as though it were an immense reservoir of electrical energy … responding to each one of its movements and reproducing the multiplicity of life'.[7] Most famously he described '*La Modernité*', the pace and change of modern experience.[8] 'The transient, the fleeting, the contingent', expressed in flickering, fast notations, was, for Baudelaire, what gave modernity

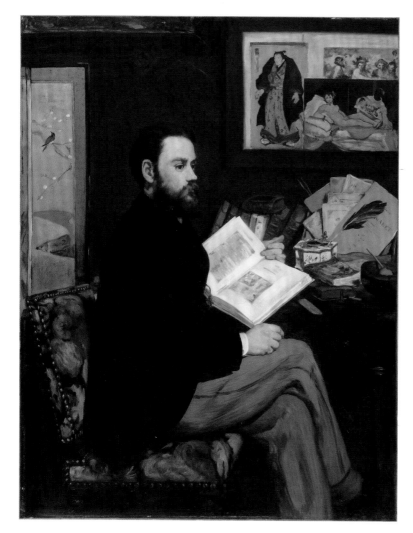

12. Édouard Manet
Émile Zola 1868
Oil paint on canvas
146.5 × 114
Musée d'Orsay, Paris

its particular poetic quality. Thus, the portraits in Manet's painting are impressions of familiar faces, briefly seen in the dappled light.

Impressionism responded to the growing appetite for art on the part of the flourishing and increasingly literate middle and artisan classes, and represented their changing world. It drew on the old masters, but also on modern novels, popular magazines, prints and the recent invention of photography, pioneered by the likes of Nadar. The abrupt, cut-off edges of *Music in the Tuileries Gardens*, the

partial figures obscured by others and their impromptu, sometimes inelegant, postures reflected the new imagery of photographs, and can also be seen in Monet's and Degas's beach scenes. Photographs and prints flattened the world into striking black-and-white compositions, which are echoed in the contrasts of light and dark that structure these paintings.

Manet's portrait of the realist novelist, Émile Zola (fig.12), shows these eclectic influences in content as well as style. Behind the writer, there is a print of Manet's most notorious tilt at the establishment, his modernisation of the classical nude in the form of a painting of a courtesan: *Olympia* (1863, Musée d'Orsay), shown at the Salon in 1865. Zola defended Manet against the scandal that resulted from this exhibition in an article that can be seen on the right-hand side of the picture. The book he is holding is a history of painting, and behind *Olympia* is a tribute to seventeenth-century Spanish art: an engraving of Diego Velázquez's *The Triumph of Bacchus* (1628, Museo del Prado).

The figure of Zola nods to the austere colouring of Spanish portraits and to the costume of the Japanese wrestler, shown in a print next to Olympia. The decorative screen to the left of the painting is also Japanese. At this time, an increasing number of objects and images were arriving in Europe from the wider world, now increasingly connected by imperial and commercial interests and new networks of steam railways and shipping. In the 1850s, Japan resumed trade with the West, and artists were amazed by the cheap woodblock prints that appeared in Paris, sometimes ending up used as wrapping paper. Impressionists saw their modern city in the *ukiyo-e* prints – or 'pictures of the floating world', depicting actors and courtesans – especially the landscape and domestic scenes. The unshaded blocks of colour and graceful, asymmetric contours of the trees in Manet's *Music in the Tuileries Gardens* register their impact, as do the strong contours and asymmetric arrangements of Monet's *The Beach at Trouville* and Degas's *Beach Scene*.

Katsushika Hokusai's famous series of colour prints, *Thirty-six Views of Mount Fuji* (c.1830–2), were especially influential. Compare, for example, his *Sazai Hall* 1829 (fig.13) with Monet's *Garden at Sainte-Adresse* 1867 (fig.14). The geometric perspective and pattern of colours in the Japanese leisure scene are adapted to the modern French terrace, and the smoky diagonals issuing from the ships take

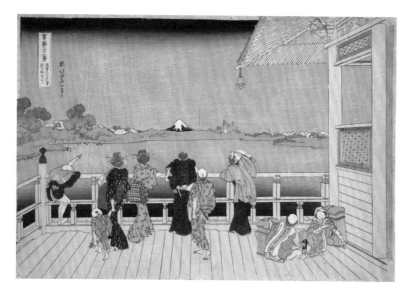

13. Katsushika Hokusai
Sazai Hall at the Temple of the Five Hundred Arhats
from the series *Thirty-six Views of Mount Fuji*
c.1830–2
Woodblock print on paper
26 × 38.7
The Metropolitan Museum of Art, New York

the place of Mount Fuji's slopes. Such strong, original compositions came to be typical in impressionist painting.

'A few poor sketches'

> I have a dream, a picture of the bathing spot at the Grenouillère, for which I've made a few poor sketches, but it is a dream. *Claude Monet, 25 September 1869*[9]

In 1869, Monet and Renoir sketched side-by-side at a shady bathing and boating resort on the Seine, nicknamed La Grenouillère, 'the frog pond'. It was a Baudelairean subject – a modern version of academic nymphs or bathers. The composition of Monet's painting (fig.25) is a long way from the layered shapes of conventional picturesque landscapes. In the spirit of Japanese prints, the horizontal of the boardwalk bisects the painting, so that the shapes of light and dark above and below echo each other. The blurring of forms, strong tonal contrasts and cut-off boats give a sense of an uncontrived, individual viewpoint, reminiscent of that provided by photography.

The artists were able to exploit new portable easels and metal tubes of paint that could be resealed with caps. They also used stiff hog's-hair brushes – held in a square shape by a metal ferrule – which allowed them to evoke the fleeting effects of moving swimmers,

14. Claude Monet
Garden at Sainte-Adresse
1867
Oil paint on canvas
98.1 × 129.9
The Metropolitan Museum
of Art, New York

water and foliage with fast graphic marks, called *'taches'*. Short horizontal strokes indicate the water and abrupt jabs of the brush animate the foliage. Technological advances in the dying and textile industries had also introduced industrially produced paints in prismatic colours; viridian, emerald and chrome greens, cadmium yellows and cobalt blue could be used to imitate the rainbow colours of light itself. Academic artists harmonised their hues, but the impressionists were reading new texts on colour theory. The chemist Michel-Eugène Chevreul, for example, had written about simultaneous contrast – the way a colour can enhance the effect of its opposite. Juxtapositions of blue and orange, yellow and purple, and red and green are common in impressionist paintings. In Renoir's picture (fig.26), an orange boat bobs in blue water, and, in Monet's, a red skirt sings out against green foliage. Yellow sunlight tends to cast

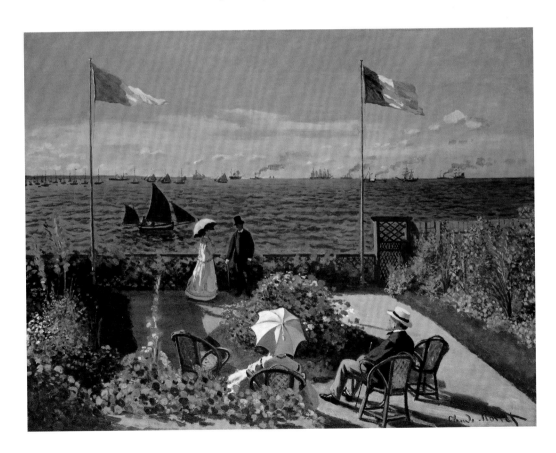

blue-purple shadows, as seen on the white dress of the woman in the centre of Renoir's picture, placed next to a woman in orange. A white ground and the use of white mixed into colours added luminosity.

At this date, plein-air paintings of this kind were thought of only as notes, used to give the sense of spontaneous 'impression' to a finished picture. More densely painted works, such as Monet's *Garden at Sainte-Adresse* and Pissarro's *Hoar Frost* were completed in the studio. Monet and Renoir never got round to finishing paintings of La Grenouillère, but one of the sketches was exhibited in the second impressionist exhibition in 1876.

Exilité

It is only when you are abroad that you realise how beautiful, grand and hospitable France is. *Camille Pissarro, 1871*[10]

By the end of the 1860s, there was some appreciation and patronage for alternative painters, but the younger generation struggled to gain recognition and make ends meet. Monet had failed to transform his sketches into a monumental modern-life painting like those with which Courbet and Manet were challenging the Academy and, in general, only modest landscapes and still lifes made their way to the Salon walls. Then, in the summer of 1870, a catastrophe occurred. The Franco-Prussian War broke out, and by September, Paris was under siege. Manet, Degas and Bazille fought, and Bazille was killed in action. Sisley and Renoir survived in the Paris outskirts through the Siege and then the 1871 Commune, a six-week popular insurrection in the capital that followed the armistice. The rebellion was bloodily put down by the government, as depicted by Manet in his lithograph, *La Barricade* 1871 (fig.15). Livings were also disrupted. Sisley's father's business was ruined and he lived in poverty for the remainder of his life. Pissarro's studio in Louveciennes was requisitioned by the Prussians, and most of his existing output, alongside works by Monet, was destroyed. Both friends had already sought sanctuary in London with their families.

Soon after their arrival in London, Monet painted his wife, Camille, in their cheap Kensington lodging house. *Meditation, Mrs Monet Sitting on a Sofa* 1871 (fig.16), is very different from the breezy *The Beach at Trouville*. As its title suggests, it is a quieter, more slowly

15. Édouard Manet
La Barricade, scène de la Commune de Paris 1871
Lithograph on paper
46.8 × 33.2
The British Museum, London

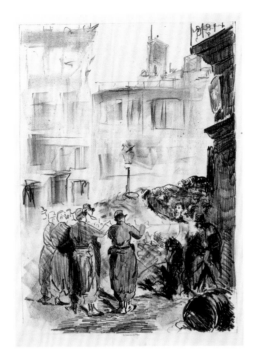

observed work. Camille is still, perhaps confined by the English weather, gazing through a window. The book in her lap is probably a Baedeker travel guide. This is an image of *'exilité'*, the disconnection and sadness of exile.

Pissarro, his partner Julie Vellay and their children settled outside London in West Norwood. Like his home in Louveciennes, it was one of the new suburbs that were springing up around cities as they were connected by rail, and Pissarro continued to paint modest landscapes. *Upper Norwood, Crystal Palace* 1871 (fig.28) – a view along an ordinary road – employed a striking, converging perspective, like that with which he had been experimenting in France. The inelegant jumble of houses, however, includes some built of English industrial red brick, and the enormous glass exhibition halls surviving from the Great Exhibition of 1851 can be seen in the background.

Two important impressionist subjects emerged during this period. London was at the forefront of the Industrial Revolution and French painters were drawn to the new spectacles it offered. Pissarro made the first impressionist paintings of railways, a motif which would

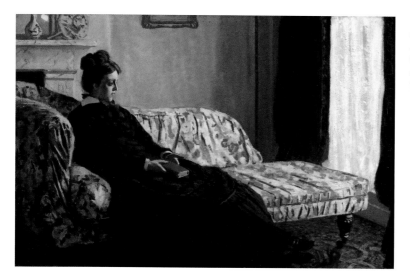

16. Claude Monet
Meditation, Mrs Monet Sitting on a Sofa 1871
Oil paint on canvas
48.2 × 74.5
Musée d'Orsay, Paris

become common. *Lordship Lane Station, Dulwich* 1871 (fig.29) shows a track freshly cut through a hill and new building developments. More important was the River Thames, with its smoke and traffic, modern bridges and embankment, and dramatic skyline. Pissarro painted the pinnacled Parliament buildings of Westminster seen beyond the iron-lattice Hungerford Bridge (sometimes known as Charing Cross Bridge), as well as the more placid environs of Hampton Court, upriver. Sisley also painted Hampton Court in 1874 in *Molesey Weir, Hampton Court, Morning* (fig.42) and *Under the Bridge at Hampton Court* (fig.43). Their viewpoints reveal the fascination the French felt for the new engineering structures spanning the Thames.

Monet, meanwhile, followed the example of the exiled Barbizon painter Charles-François Daubigny and painted the less picturesque docks, warehouses and tall ships downriver. The two met in London and may have worked together, and the older artist's *St Paul's from the Surrey Side* 1871–3 (fig.30), has much in common with *The Thames below Westminster* 1871 (fig.32). Monet remembered his stay in England as a 'miserable time' and he and Pissarro returned to France as soon as the conflict was over, but both would return and paint the Thames again.[11]

'New Painting'

> they are trying to create from scratch a wholly modern art, an art imbued with our surroundings, our sentiments, and the things of our age. *Edmond Duranty, 1876*[12]

In London, Monet and Pissarro met another fellow exile, the dealer Paul Durand-Ruel, and, on their return to France, he became an important ally and supporter of the impressionist group. There was already a market for Barbizon landscapes among the growing urban population, nostalgic for the countryside, and Durand-Ruel encouraged clients to appreciate the bold application of paint and freer compositions of the newer painting. A sale of Durand-Ruel's stock in 1875 contained oil paintings and watercolours by Monet, Morisot, Renoir and Sisley. Most of the works were landscapes, with some domestic scenes. Renoir's dynamically brushed *The Gust of Wind* 1872 (fig.35), executed in one sitting, was among them, as were several of Sisley's lively views of the Thames, including *Molesey Weir, Hampton Court, Morning*. In 1876, Edmond Duranty wrote an essay entitled '*La Nouvelle Peinture*' (The New Painting), defending the artists supported by Durand-Ruel.

Durand-Ruel and other dealers provided an alternative career to that offered by the Academy and impressionist landscapes were seen and sold at smaller, private exhibitions that catered for bourgeois Parisian interests and tastes. Like the Thames, the river and parks around Paris were a playground for all classes. Berthe Morisot's *Summer's Day* c.1879 (fig.17), displayed in the fifth impressionist exhibition, in 1880, depicts two women in a boat on a lake in the Bois de Boulogne, while a horse-drawn carriage moves along in the background. Renoir's *La Promenade* 1870 (fig.27) shows a couple more immersed in nature – the young man helping a young woman up the river bank. Both artists employed a distinctive, individual brushwork to enliven their scenes. Renoir's strokes are feathery, conveying the moving foliage and dappled light, while Morisot's varied and exciting graphic marks summon the glitter of the sunlight and gaiety of the girls.

London's city parks were less formal than Parisian gardens such as the Tuileries and attracted the attention of impressionists during their exile and on subsequent visits (fig.33). British sporting life,

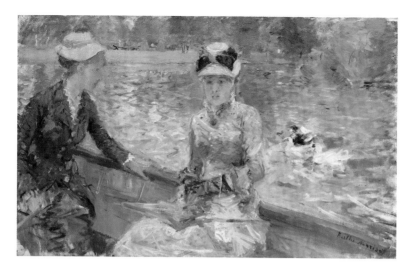

17. Berthe Morisot
Summer's Day c.1879
Oil paint on canvas
45.7 × 75.2
The National Gallery,
London

regattas and racing also became fashionable in France. Degas, especially, sketched at the racecourse at Longchamps. *At the Races in the Countryside* 1872 (fig.36) was one of the first paintings he sold to Durand-Ruel and appeared in the first impressionist exhibition. It depicted Degas's friend Paul Valpinçon and his wife with their son and pet dog. It is a modern family, represented with a Baudelairean irony; the unusual composition and setting subverts the conventions of domestic portraiture and the woman under the parasol, with the child on her lap, is not the mother, but a professional wet-nurse.

Impressionists reflected their suburban lives in domestic scenes including their friends and family. Women impressionists could frequent respectable sites of leisure such as parks, race meetings and theatres, but their most accessible subjects were at home. Morisot's most famous painting, *The Cradle* 1872 (fig.37), displayed at the first impressionist exhibition, shows her sister Edma watching over her sleeping daughter, Blanche. It was the first of Morisot's images to update the well-established theme of mother and child, but, like Degas's work, it interrogates traditional expectations of the theme. Morisot's focus is not so much the physical, but the visual relationship between the woman and the baby. In keeping with her interests as an artist, she eschews the conventional poses of cradling and feeding, in favour of something more contemplative, represented by Edma's gaze, the angle of which is reinforced by the diagonal of the curtain

behind. This theme is underlined by the answering diagonal of the semi-transparent covering that Edma draws between the spectator and the child.

'The Heroism of Modern Life'

> The pageant of fashionable life and the thousands of floating existences … which drift about in the underworld of a great city … all prove to us that we have only to open our eyes to recognise our heroism. *Charles Baudelaire, 1846*[13]

The impressionists also represented Paris as it returned to normal after the war. Monet's *Boulevard des Capucines* 1873–4 (fig.40) shows the straight boulevards and smart new apartment blocks which were introduced before the war by Napoleon III, who spent 50 million francs redefining and redeveloping the city under the supervision of Georges-Eugène, Baron Haussmann. We view the street from a wrought-iron balcony of one of the apartments, observing the crowd below. Haussmann made such streets into places of leisure, installing trees, kiosks and benches at regular intervals, so that the city became a kind of public theatre where classes mixed and the well-to-do displayed their wealth.

Monet was, again, drawn to feats of engineering, and painted eleven views of the Gare Saint-Lazare, near his studio, seven of which he exhibited in the third impressionist exhibition, in 1877. They were an early exploration of the practice of working in series; Monet experimented with different positions, offering different geometrical shapes and effects of light and atmosphere. The steam from the trains provided him with an atmosphere even more dramatic than the pollution of London.

Manet and Gustave Caillebotte (1848–94) lived nearby and painted the same station. A Salon painter, Caillebotte's modern-life subjects had attracted criticism, and in 1876 he accepted Degas's invitation to show in the impressionist exhibition. His picture of *Le Pont de l'Europe* 1876 (fig.47), an iron-lattice bridge across the station, was exhibited in the same year as Monet's group. Although Caillebotte worked in the studio and did not adopt the fast, summary brushing of the impressionists, he addressed modern life on the heroic scale of academic history painting with an unconventional,

oblique perspective, inspired by bridges in Utagawa Hiroshige's *One Hundred Famous Views of Edo* (1857). In Caillebotte's picture no one's gaze meets another's and relationships are obscure. An ownerless dog trots along purposefully, a working man rests on the bridge. Caillebotte allows us to experience a motif beloved of Baudelaire: the brief, ambiguous encounter of the passers-by. The affluent-looking man in the foreground, a flâneur, half turns to a woman behind him. They may or may not be together and she could be a relative, or not. Working women were coming to the city to make a living in domestic service and in new commercial trades such as the retail and fashion industries, but the availability of affordable clothes and accessories to wage-earners resulted in middle-class anxieties about the difficulty of distinguishing the newcomers from their own kind.

Impressionist artists depicted other modern Parisians. Caillebotte's *The Floor Scrapers* 1875 (fig.18), showing men refurbishing an apartment, elevated the urban labourer to the status of the academic nude and was rejected from the Salon and exhibited at the second impressionist exhibition. Degas was also interested in urban professions and represented the hard life of shopworkers, laundresses and performers. The sex trade was a common topic in newspapers, novels and prints, and Degas's monotype augmented with pastel, *Women in Front of a Café, Evening* c.1877 (fig.19), shown in the third impressionist exhibition, combined this subject with the theme of the street encounter. It depicts women relaxing while on display to passers-by. We see industrially produced plate glass, which was opening up shops and restaurants, and, beyond this, the new gas lights that were transforming nightlife. The work suggests the alienation of the city; shadowy pedestrians are anonymous and the women are not convivial – again, gazes do not meet. One woman bites her thumb in an ambiguous gesture that may be either an insult or invitation to someone out of view.

Degas continued to create his impressionist scenes from models in the studio and, during the 1880s, he executed a series of pastels of women posed as though they were 'bathing, washing, drying, wiping themselves, combing their hair or having it combed'.[14] Like Manet's *Olympia*, they cast a contemporary eye on the long tradition of the classical nude. Improved water facilities and mass-produced and marketed soap had made private bathing more widely available

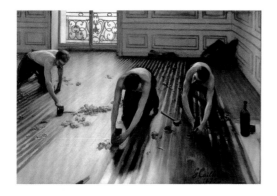
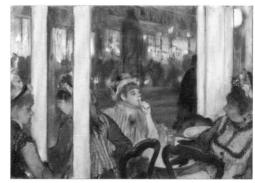

18. Gustave Caillebotte
The Floor Scrapers 1875
Oil paint on canvas
102 × 146.5
Musée d'Orsay, Paris

19. Edgar Degas
*Women in Front of a Café,
Evening* c.1877
Pastel on paper
55 × 72
Musée d'Orsay, Paris

and it was especially associated with women who worked in intimate roles, such as artist's models. The white towels in *Woman in a Tub* c.1883 (fig.51) were also a novelty, provided by the new laundries that Haussmann had introduced to the city. When a suite of eleven of these pastels was included in the eighth and last impressionist exhibition, in 1886, critics commented on the sense that the women seemed unaware that they were being looked at, as though observed through a keyhole. The slightly open door in *Woman in a Tub* hints at this voyeurism. The nudes attracted praise for their modernity and criticism from those who found the figures too ordinary and vulgar. Their beauty lay, instead, in Degas's weaving of coloured pastel strokes, building up an almost opalescent, vibrating effect of light over the surfaces of skin, metal and fabric. The clear geometric vertical of the door and ellipse of the tub frame the pale figure and towels in three areas of blue, red and gold.

Impressionists recorded leisure as well as work. Montmartre, a semi-rural area not far from Paris, became the location of dance and music halls popular with the working class. Renoir's *Dance at Le Moulin de la Galette* 1876 (fig.46), exhibited at the third impressionist exhibition, conveys the energy of a vivacious crowd dancing in their Sunday best on the imposing scale of a Salon painting. Not far away was the Circus Fernando, where Degas made a series of drawings on the spot. He was able to record the extreme pose of the acclaimed acrobat, Miss La La, spinning nearly twenty metres above the crowd on a rope held in her teeth (fig.50). Equally spontaneous are Degas's pastel monotypes of café-concerts. His *Café-Concert at Les Ambassadeurs* 1876–7 (fig.49) placed the viewer among the crowd

in a restaurant-nightclub in the centre of Paris. We look across the motley orchestra to the singer, distorted by the footlights, whipping up the audience with her gestures as she performs a music-hall song.

The opera provided women artists with modern-life subjects to which they had access. The American, Mary Cassatt, an associate of Degas and Morisot, exhibited in the last three impressionist exhibitions, between 1879 and 1886. She painted boxes at the opera and theatre several times. *In the Loge* 1878 (fig.45) shows a woman as an intent observer rather than a decorated object of the casual gaze. She ignores the men and women looking at each other in the background, including a man leaning eagerly over the balcony to stare at her through his glasses.

Degas's interest in the opera lay behind the scenes; the effort and *ennui* of the young working-class girls who danced in the ballets became one of his most abiding preoccupations. When he could, he sought access to the rehearsal rooms and wings, but most of his representations were painted, as usual, from models and props, sketches and photographs. *The Rehearsal* c.1874 (fig.41), is an ambitious early example. Its photographic techniques – the cut-off figures and spiral staircase – give us the sense that we are looking from the margins into a private world. Dancers relax, their diaphanous costumes attended to by an elderly woman in incongruous tartan, while others practise in mechanical formation.

Synthesis

Ever since I turned sixty, I have had the idea of undertaking, for each of the types of motif which had in turn shared my attention, a sort of synthesis in which I would sum up in one canvas, sometimes two, my past impressions and sensations. *Claude Monet, c.1900*[15]

In the 1880s, the impressionist painters gained success, but grew apart and explored more emotional and spiritual perspectives, by individual paths. Some criticised the plein-air method as too sketchy and spent more time in the studio. Renoir visited Italy and turned to pursuing beauty and permanence through more finished, classical compositions, often nudes. Pissarro associated with so-called neo-impressionists, experimenting with the science of colour, applying

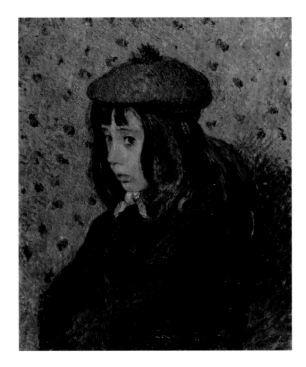

20. Camille Pissarro
Portrait of Félix Pissarro
1881
Oil paint on canvas
55.2 × 46.4
Tate

his prismatic hues systematically, in small dabs. Monet achieved more considered paintings by working in series. In 1890, he moved to Giverny in rural Normandy, where he was able to refine his images in another way, by prearranging his subjects in the form of his carefully cultivated lily pond and garden.

To achieve this, Monet wished to give 'instantaneity' the permanence of art.[16] He would often work on several canvases at a time. *Poplars on the Epte* 1891 (fig.21) is one of twenty-three representations of this row of trees, swapped over every few minutes while the artist was working, as the sky and its reflections in the river changed. The battle was given added poignancy by the imminent felling of the trees, and Monet paid the lumberman involved to gain a few months longer. He valued the artistically satisfying prospect which the poplars offered. The 'S' shape of the receding foliage and trunks, simultaneously receding and flat, reminded him of Hiroshige prints, and he refined it further in the studio. Durand-Ruel exhibited a group the following year and the effect of the fifteen pictures, each subtly different in light and atmosphere, must have been breathtaking.

Impressionists developed their art by reconsidering familiar motifs. Degas's *Blue Dancers* c.1890 (fig.53), a large painting that remained in his studio when he died, was one of a series of gorgeously coloured late paintings made from models or earlier paintings and sketches. As its title suggests, it transformed the figures into a decorative arrangement – a staccato rhythm of arms and legs united by swathes of blue. The brushstrokes were influenced by the rainbow marks of his pastels, and the light filtering into the wings from the stage is represented by dabs of pure colour, some made by the artist's thumbs. Similarly, a later variation on Degas's pictures of shop-workers, *The Millinery Shop* 1879–86 (fig.52), focused on decorative possibilities. The auburn hair, yellow gloves and green dress of the assistant are a mere foil for the orange, green and yellow hats arranged across the canvas like a bouquet.

Pissarro returned to townscapes painted from upper-floor windows; the high vantage points flattened the views and strengthened the sense of pattern. In 1897, he depicted prospects of the boulevard Montmartre from the Hôtel de Russie, including a night scene (fig.56). Receding orthogonals structure the ephemeral effects of shadows and gaslight flickering over figures and carriages, glass and stone, in the rainy street. In the 1890s, both Pissarro and Monet revisited locations in London. In 1901, Monet painted three views of Leicester Square at night from a similar perspective at the Lyric Club – an almost entirely abstract kaleidoscope of coloured light is the result (fig.57).

Monet was in London to repaint the Thames, of which he eventually made about eighty depictions. He painted the Palace of Westminster backlit by evening light to get the full effect of the 'envelope' of foggy, polluted air (figs.59, 60). 'The fog in London assumes all sorts of colours', he remarked. 'My practiced eye has found that objects change in appearance … more and quicker than in any other atmosphere, and the difficulty is to get every change down on canvas.'[17] Durand-Ruel exhibited thirty-seven of the Thames series in 1904, to wide acclaim.

Monet's most famous late series, depicting the water lilies on his garden pond, exceeded the scale and dignity of academic pictures, immortalising the fleeting moment in epic works (fig.61). Some of these took on the graceful proportions of a classical frieze or a Japanese scroll and were extended to fill the field of vision, many

21. Claude Monet
Poplars on the Epte 1891
Oil paint on canvas
92.4 × 73.7
Tate

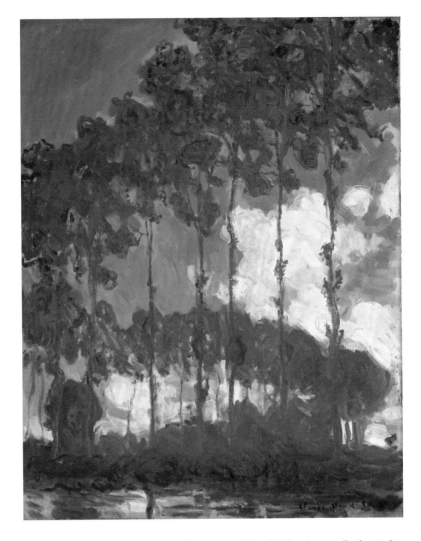

measuring six metres in length, or more. The horizon was eliminated, so that the surface of the canvas equates to the surface of the water, a beguiling interplay of reflected sky and willow, water-lily leaves and flowers. The paintings, made entirely in the studio, excluded the outside world while, not far away, World War One was raging. On Armistice Day in 1918, Monet donated a series, *Grandes Décorations*, as a 'bouquet of flowers' to the French nation.[18]

22. Eugène Boudin
Beach Scene, Trouville
c.1860–70
Oil paint on wood
21.6 × 45.8
The National Gallery,
London

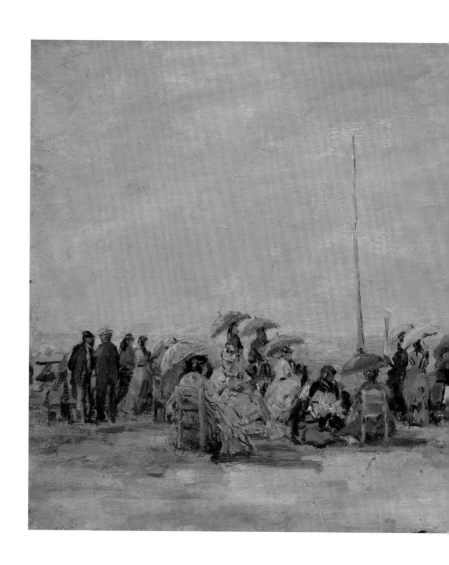

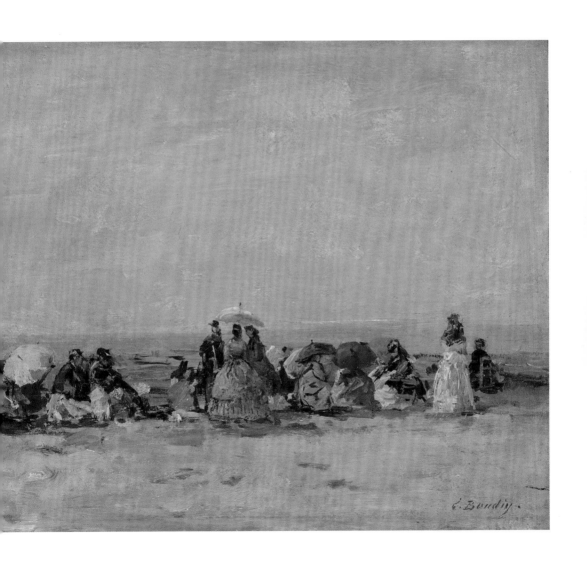

23. Édouard Manet
*Music in the Tuileries
Gardens* 1862
Oil paint on canvas
76.2 × 118.1
The National Gallery,
London

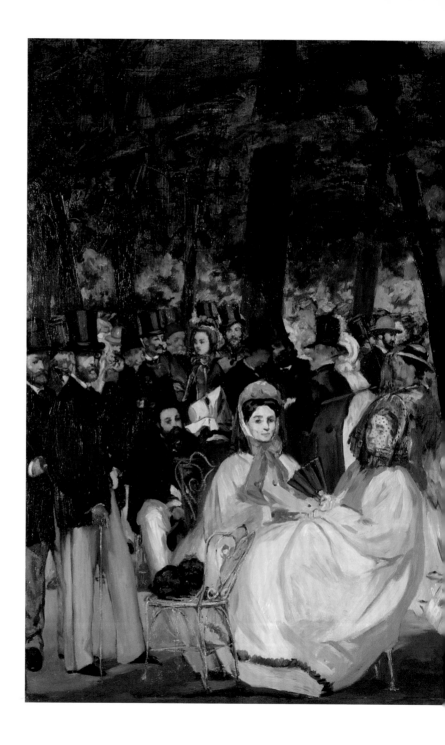

24. Pierre-Auguste Renoir
Frédéric Bazille 1867
Oil paint on canvas
105 × 73.5
Musée d'Orsay, Paris

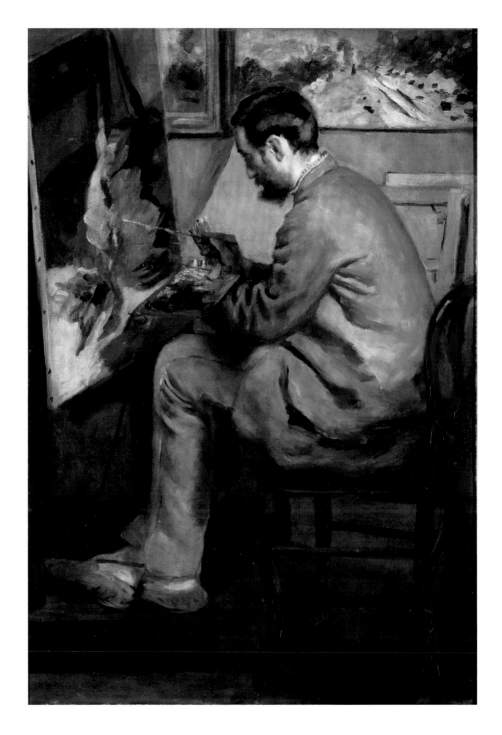

25. Claude Monet
Bathers at La Grenouillère
1869
Oil paint on canvas
73 × 92
The National Gallery,
London

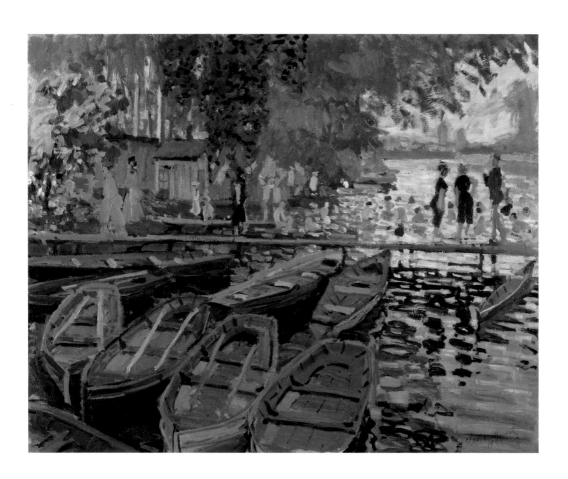

26. Pierre-Auguste Renoir
La Grenouillère 1869
Oil paint on canvas
66.5 × 81
Nationalmuseum,
Stockholm

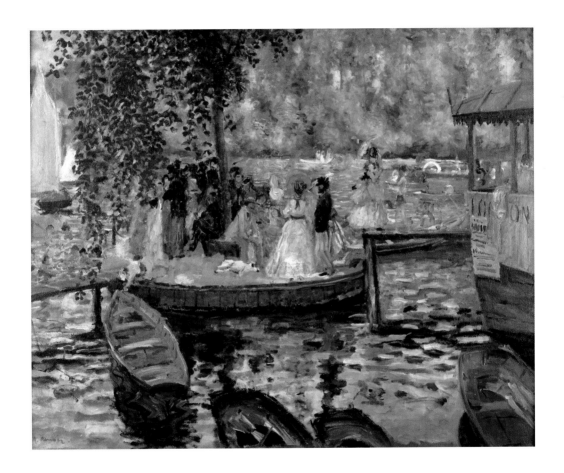

27. Pierre-Auguste Renoir
La Promenade 1870
Oil paint on canvas
81.3 × 64.8
Getty Center, Los Angeles

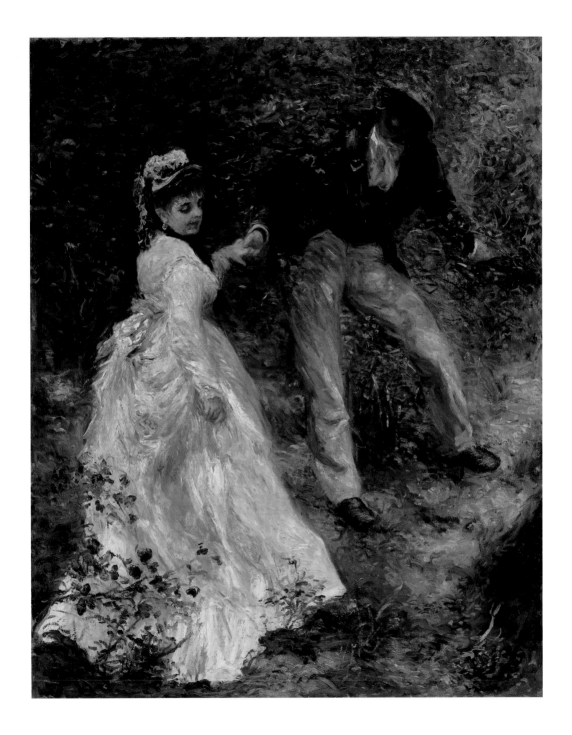

28. Camille Pissarro
Upper Norwood, Crystal Palace, London 1871
Oil paint on canvas
40 × 51
Private collection

29. Camille Pissarro
*Lordship Lane Station,
Dulwich* 1871
Oil paint on canvas
44.5 × 72.5
The Samuel Courtauld
Trust, The Courtauld
Gallery, London

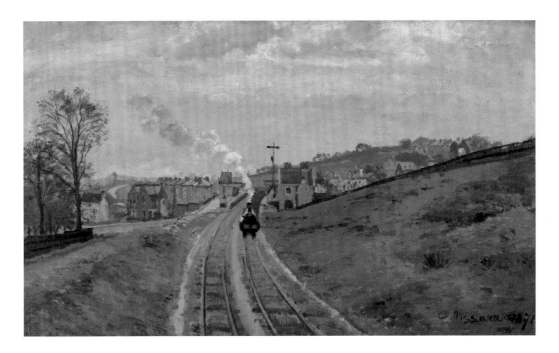

30. Charles-François
Daubigny
*St Paul's from the Surrey
Side* 1871–3
Oil paint on canvas
44.5 × 81
The National Gallery,
London

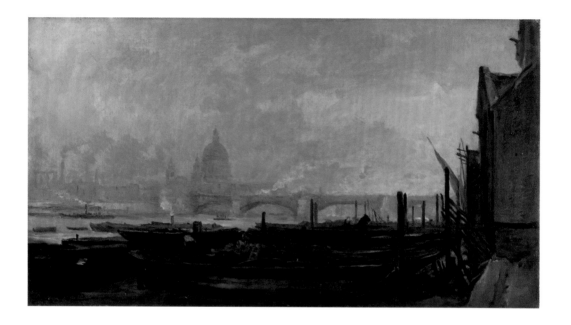

31. Claude Monet
The Thames at London
1871
Oil paint on canvas
48.5 × 74.5
National Museum of
Wales, Cardiff

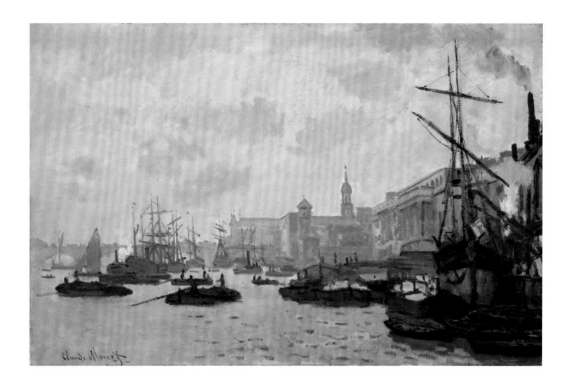

32. Claude Monet
*The Thames below
Westminster* 1871
Oil paint on canvas
47 × 73
The National Gallery,
London

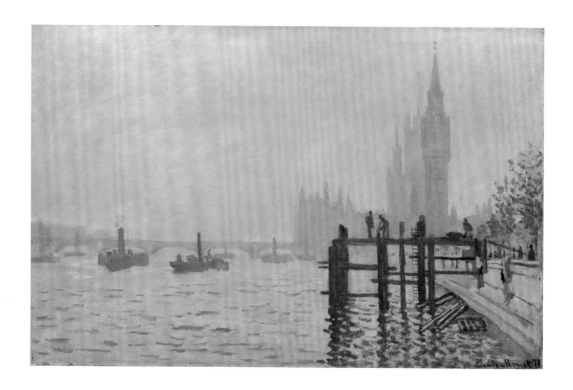

33. Claude Monet
Hyde Park 1871
Oil paint on canvas
40.5 × 74
Rhode Island School of
Design Museum

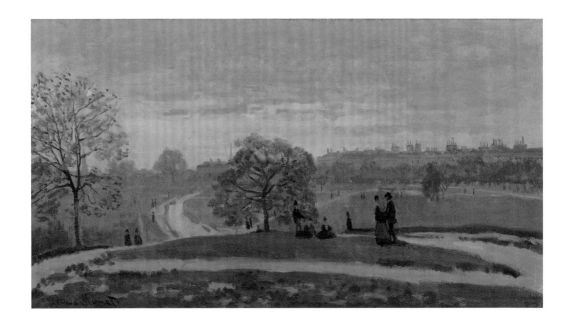

34. Claude Monet
Impression, Sunrise 1872
Oil paint on canvas
48 × 63
Musée Marmottan, Paris

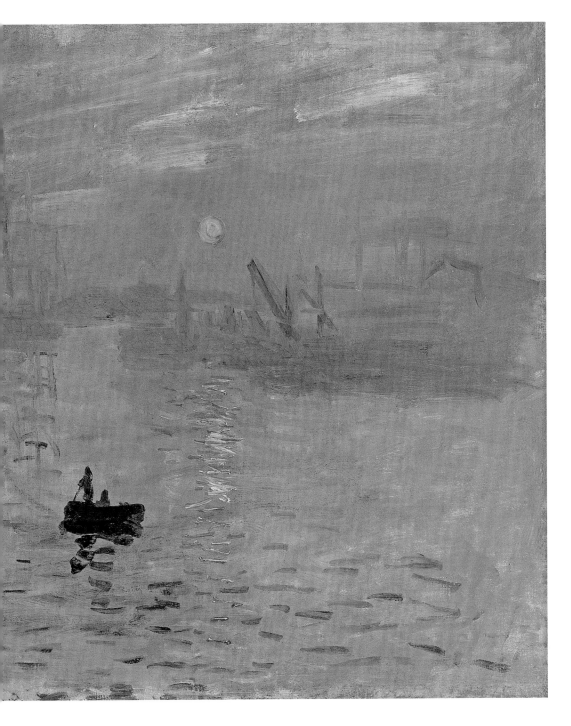

35. Pierre-Auguste Renoir
The Gust of Wind 1872
Oil paint on canvas
52 × 82
Fitzwilliam Museum,
Cambridge

36. Edgar Degas
At the Races in the
Countryside 1869
Oil paint on canvas
36.5 × 55.9
Museum of Fine Arts,
Boston

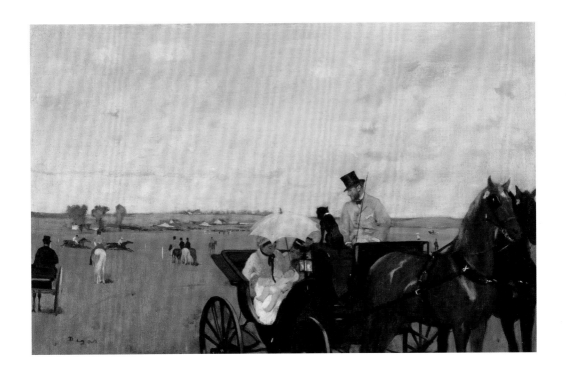

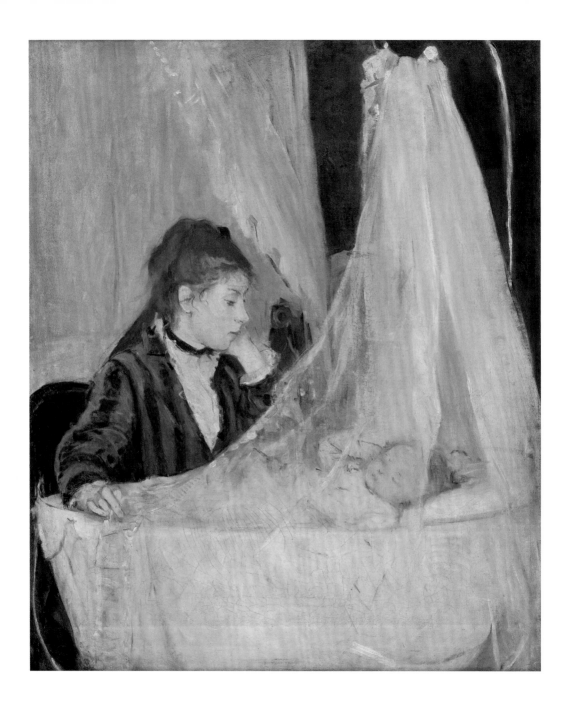

37. Berthe Morisot
The Cradle 1872
Oil paint on canvas
56 × 46
Musée d'Orsay, Paris

38. Édouard Manet
Berthe Morisot with
a Bouquet of Violets 1872
Oil paint on canvas
55 × 40
Musée d'Orsay, Paris

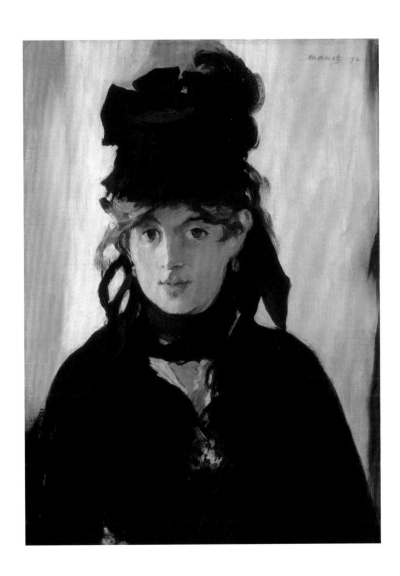

39. Camille Pissarro
Hoar Frost 1873
Oil paint on canvas
65 × 93
Musée d'Orsay, Paris

40. Claude Monet
Boulevard des Capucines
1873–4
Oil paint on canvas
80.3 × 60.3
Nelson-Atkins Museum
of Art, Kansas City

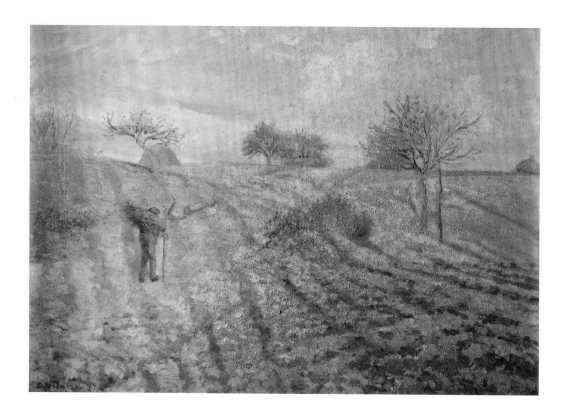

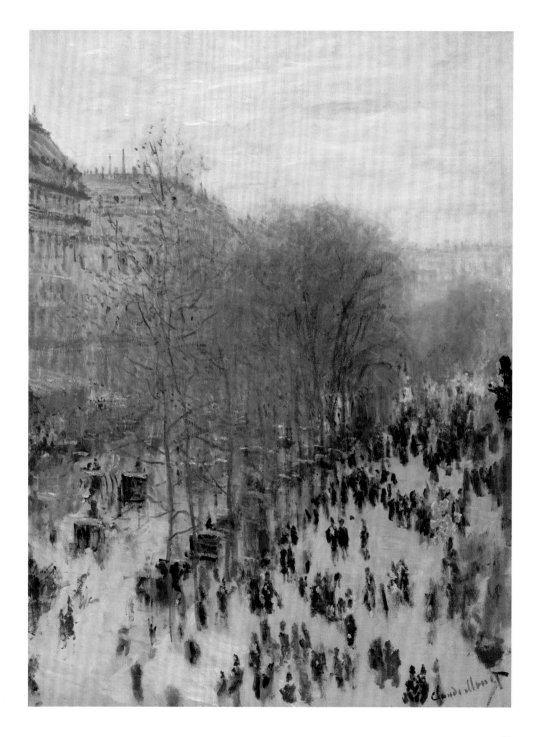

41. Edgar Degas
The Rehearsal c.1874
Oil paint on canvas
58.4 × 83.8
The Burrell Collection,
Glasgow

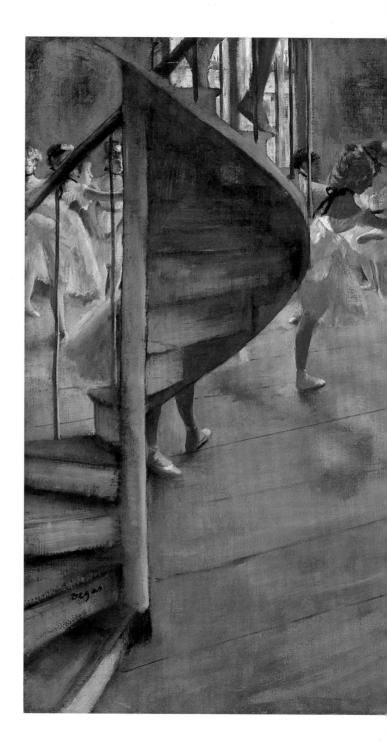

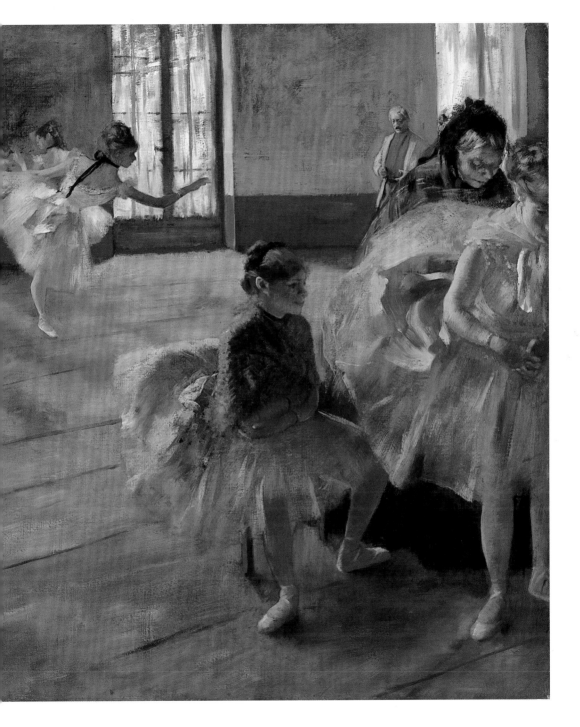

42. Alfred Sisley
Molesey Weir, Hampton
Court, Morning 1874
Oil paint on canvas
51.1 × 68.8
Scottish National Gallery,
Edinburgh

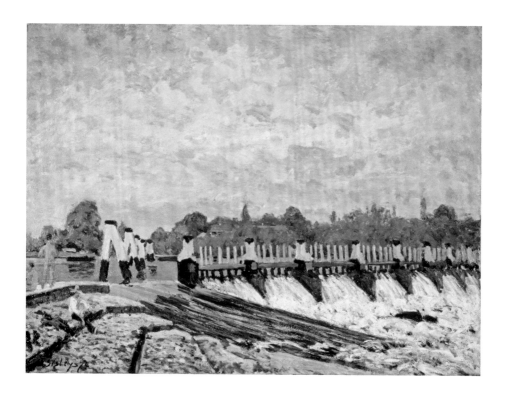

43. Alfred Sisley
Under the Bridge at Hampton Court 1874
Oil paint on canvas
50 × 76
Kunstmuseum Winterthur,
Switzerland

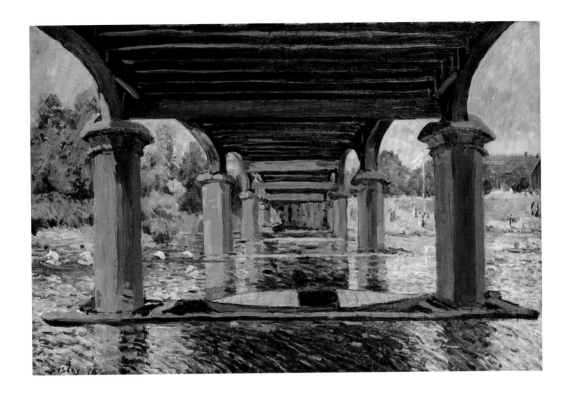

44. Pierre-Auguste Renoir
The Theatre Box 1874
Oil paint on canvas
80 × 63.5
The Samuel Courtauld
Trust, The Courtauld
Gallery, London

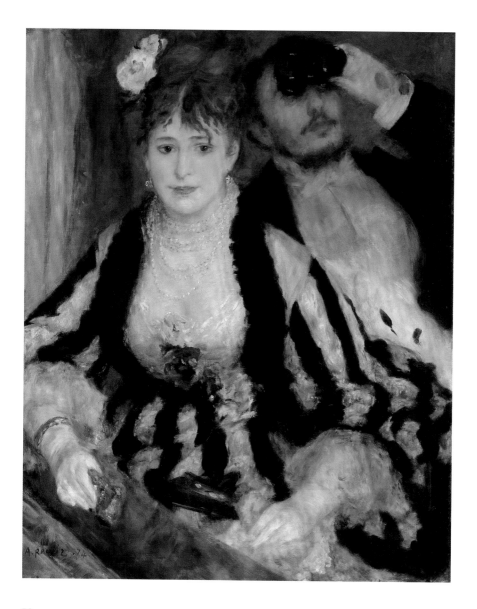

45. Mary Cassatt
In the Loge 1878
Oil paint on canvas
81.3 × 66
Museum of Fine Arts,
Boston

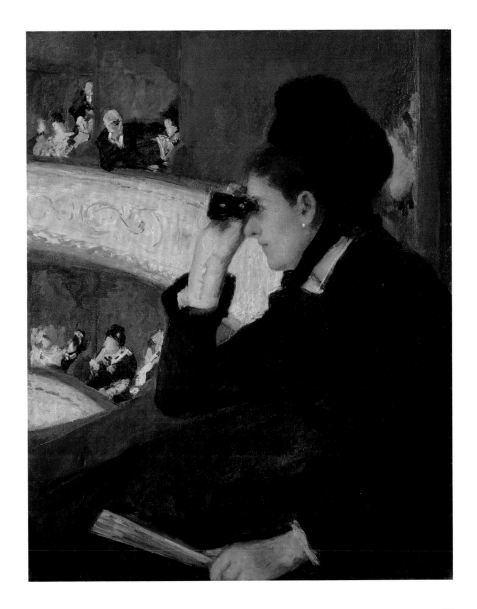

46. Auguste Renoir
Dance at Le Moulin de la Galette 1876
Oil paint on canvas
131 × 175
Musée d'Orsay, Paris

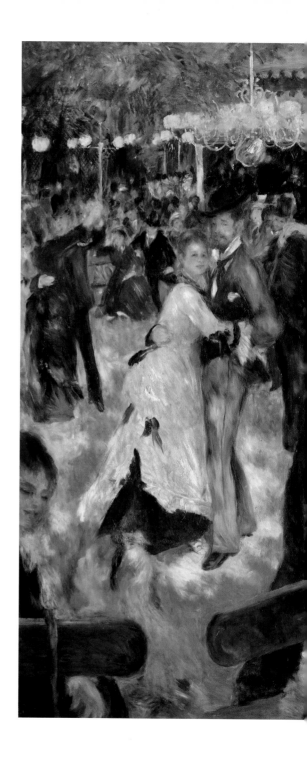

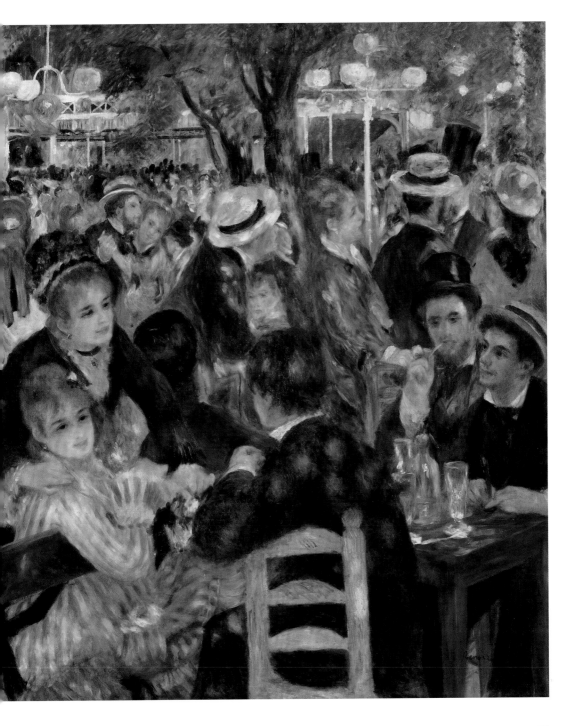

47. Gustave Caillebotte
The Pont de l'Europe 1876
Oil paint on canvas
125 × 181
Association des Amis du
Petit Palais, Geneva

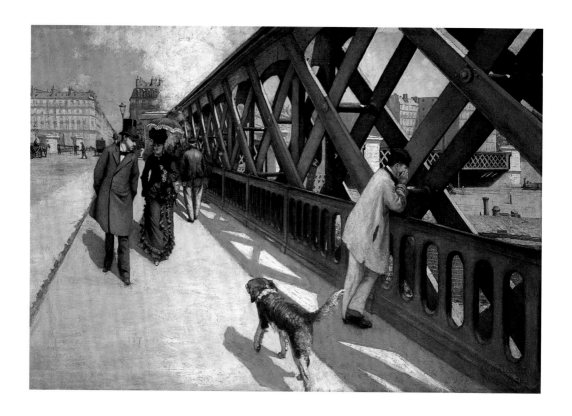

48. Claude Monet
Gare Saint-Lazare 1877
Oil paint on canvas
75 × 104
Musée d'Orsay, Paris

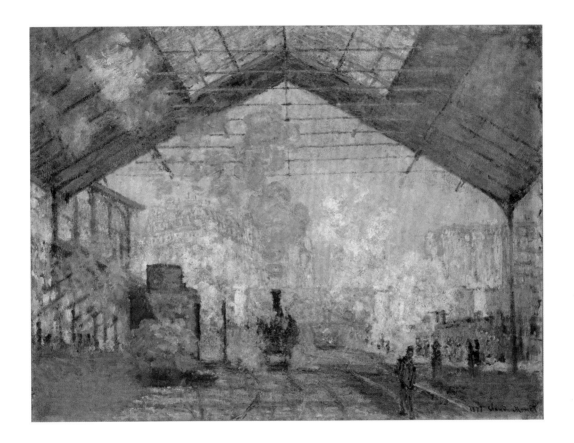

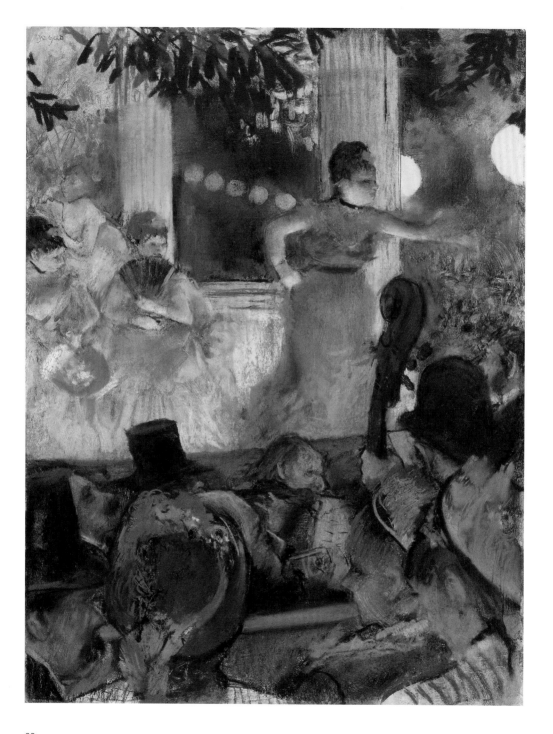

49. Edgar Degas
Café-Concert at Les Ambassadeurs 1876–7
Pastel on monotype
37 × 26
Musée des Beaux Arts de Lyon

50. Edgar Degas
Miss La La at the Cirque Fernando 1879
Pastel on paper
61 × 47.6
Tate

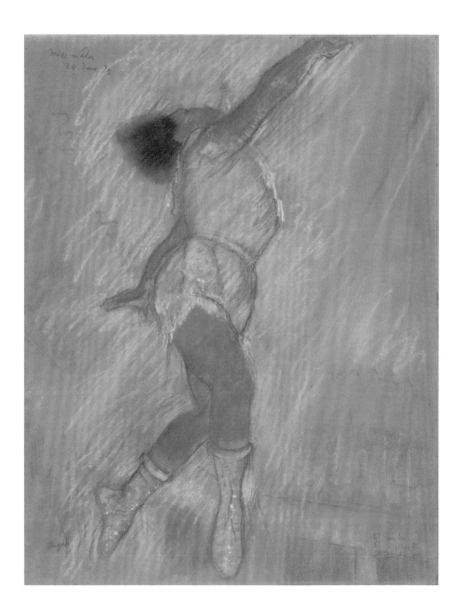

51. Edgar Degas
Woman in a Tub c.1883
Pastel on paper
70 × 70
Tate

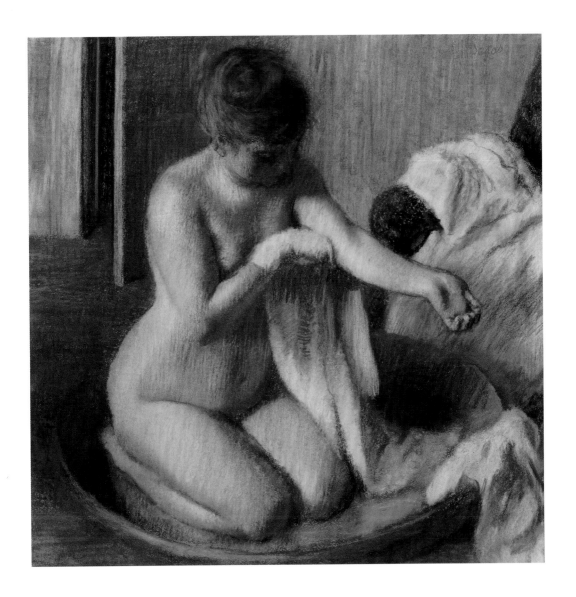

52. Edgar Degas
The Millinery Shop
1879–86
Oil paint on canvas
100 × 110.7
Art Institute of Chicago

53. Edgar Degas
Blue Dancers c.1890
Oil paint on canvas
85.3 × 75.3
Musée d'Orsay, Paris

54. Camille Pissarro
*Rhododendron Dell
at Kew* 1892
Oil paint on canvas
64 × 75
Private collection, USA

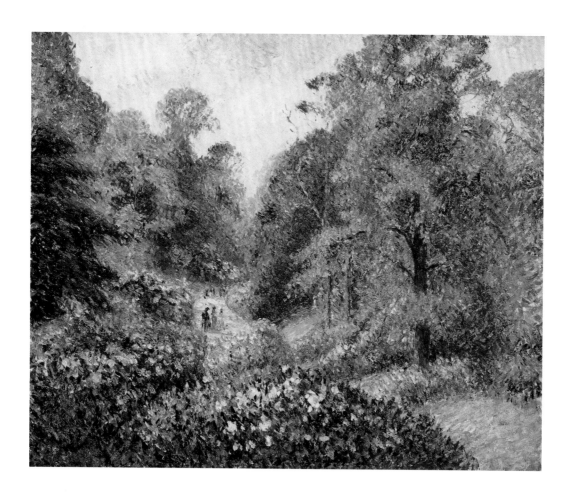

55. Camille Pissarro
*Saint Anne's Church
at Kew* 1892
Oil paint on canvas
54.8 × 46
From the collection of
Professor Mark Kaufman

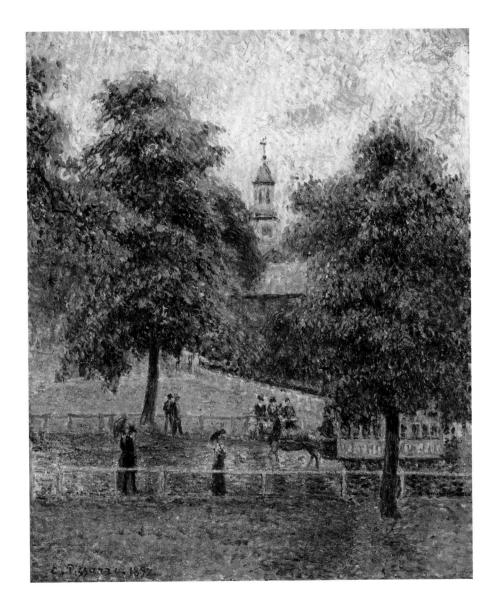

56. Camille Pissarro
*The Boulevard Montmartre
at Night* 1897
Oil paint on canvas
53.3 × 64.8
The National Gallery,
London

57. Claude Monet
Leicester Square 1901
Oil paint on canvas
80.5 × 64.8
Collection Fondation
Jean et Suzanne Planque,
deposited at Musée
Granet, Aix-en-Provence

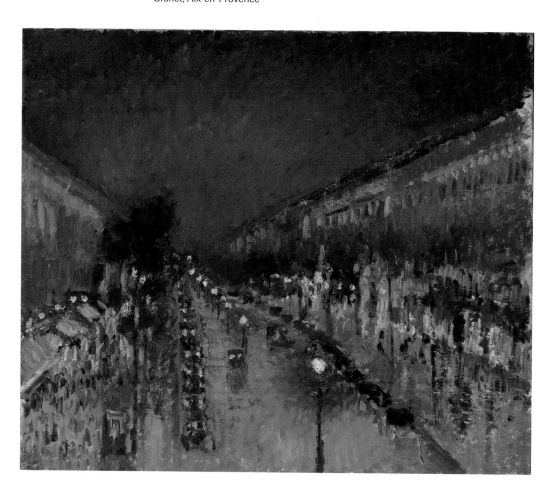

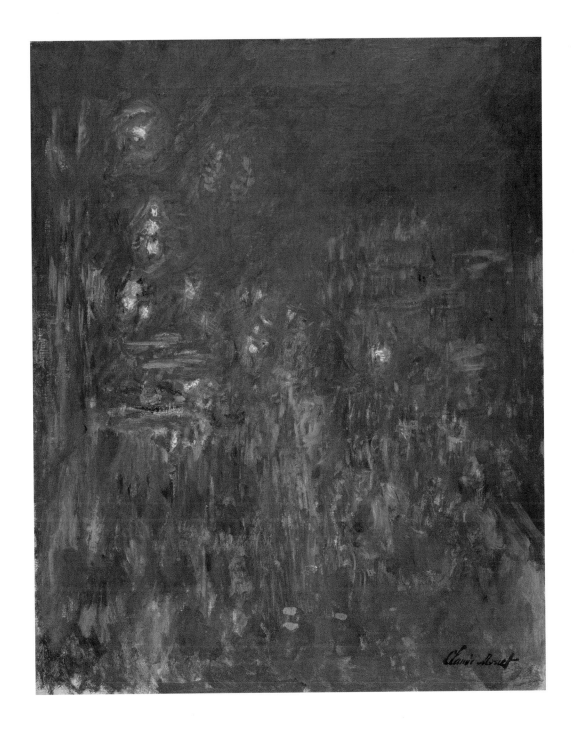

58. Claude Monet
Charing Cross Bridge
1899–1903
Oil paint on canvas
73.4 × 100.3
Musée des Beaux-Arts,
Lyons

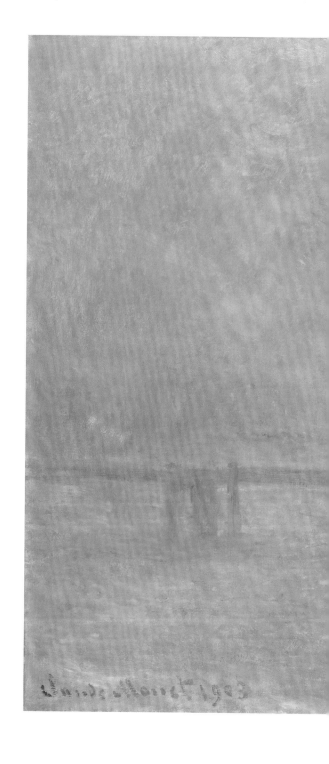

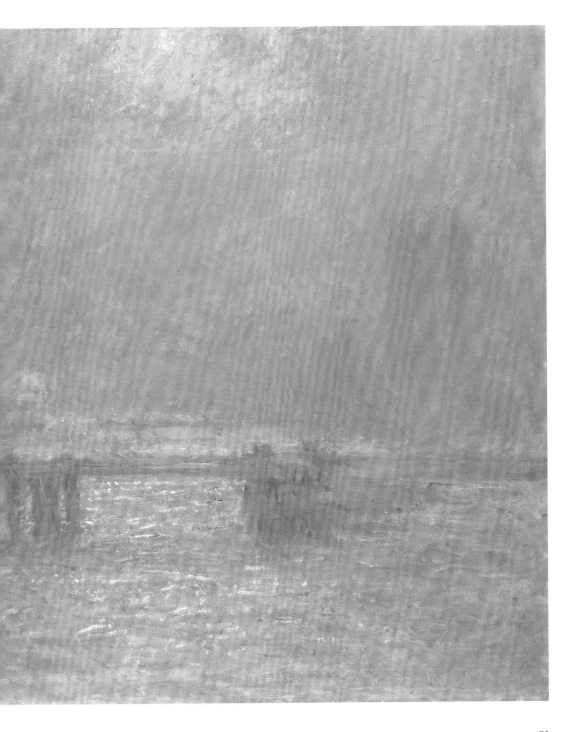

59. Claude Monet
Houses of Parliament,
Sunlight Effect 1903
Oil paint on canvas
81.3 × 92.1
Brooklyn Museum of Art

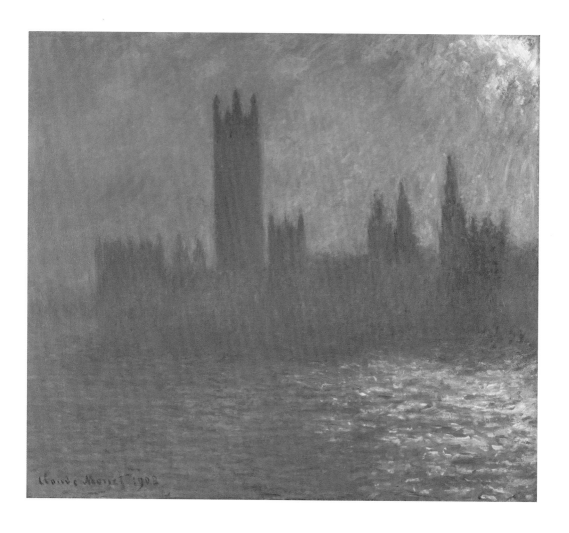

60. Claude Monet
Houses of Parliament,
Sunset 1904
Oil paint on canvas
81 × 92
Kunstmuseen, Krefeld,
Germany

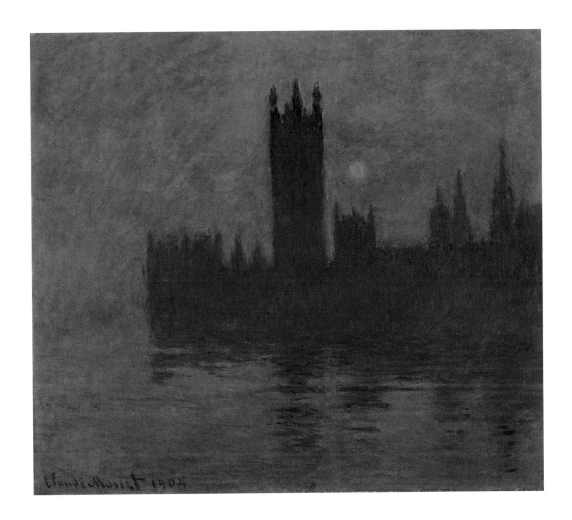

61. Claude Monet
Water Lilies, Sunset
after 1914
Oil paint on canvas
200 × 600
Musée de l'Orangerie,
Paris

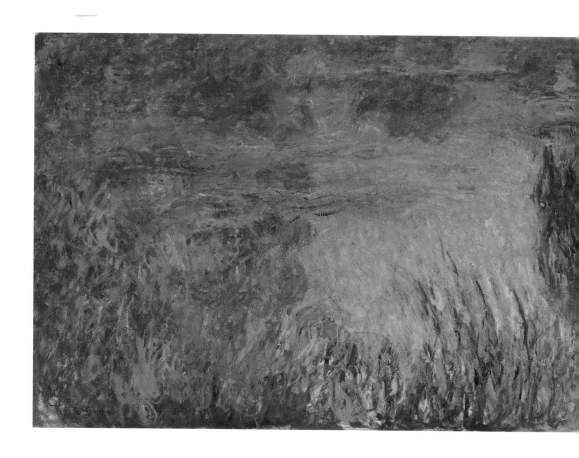

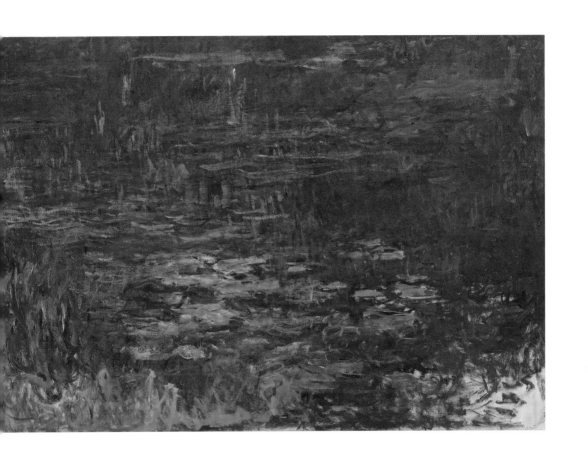

Notes

1. David Hume, *Philosophical Essays Concerning Human Understanding*, London 1748, p.23.

2. Louis Leroy, 'L'Exposition des impressionnistes', *Le Charivari*, 25 April 1874, pp.79–80.

3. Ibid.

4. Jules Castagnary, 'Exposition du Boulevard des Capucines – Les Impressionnistes', *Le Siècle*, 29 April 1874, p.3.

5. Eugène Boudin, quoted in John Rewald, *The History of Impressionism*, revised edn, Museum of Modern Art, New York 1973, p.38.

6. Charles Baudelaire, 'The Painter of Modern Life', *Le Figaro*, 1863, quoted in Charles Baudelaire, *The Painter of Modern life and Other Essays*, trans. and ed. by Jonathan Mayne, London 1964, p.9.

7. Ibid.

8. Ibid., pp.13–14.

9. Claude Monet, letter to Frédéric Bazille, 25 September 1869, in Daniel Wildenstein, *Claude Monet: Biographie et catalogue raisonné*, 5 vols, Bibliothèque des Arts, Lausanne and Paris 1974–91, vol.1, 1974, p.427.

10. Camille Pissarro, letter to Andre Duret, c.1871, in *Correspondance de Camille Pissarro*, ed. by Janine Bailly-Herzberg, Paris 1980, p.64.

11. Claude Monet, letter to Alice Monet, 16 March 1900, in Wildenstein 1974, no.1530.

12. Edmond Duranty, *La Nouvelle Peinture, du groupe d'artistes qui expose dans les galleries Durand-Ruel*, Paris 1876, p.11.

13. Charles Baudelaire, 'The Salon of 1846', quoted in *Art in Paris, 1845–1862: Salons and Other Exhibitions Reviewed by Charles Baudelaire*, trans. and ed. by Jonathan Mayne, London 1965, p.118.

14. *Catalogue de la 8ème exposition de peinture*, exh. cat., 1 rue Lafitte, Paris 1886, pp.6–7.

15. Claude Monet, letter to François Thiébault-Sisson, c.1900, quoted in John House, *Monet: Nature into Art*, New Haven and London 1986, p.31.

16. Claude Monet, letter to Gustave Geffroy, 7 October 1890, in Wildenstein 1974, vol.3, w.1076.

17. Quoted in Emma Bullet, 'Macmonnies, the sculptor, working hard as a painter', *Eagle*, 8 September 1901, quoted in John House, 'The Impressionist Vision of London', in Ira Bruce Nadel and F.S. Schwarzbach (eds), *Victorian Artists and the City: A Collection of Critical Essays*, New York and Oxford 1980, p.88.

18. Gustave Geffroy, *Claude Monet, sa vie, son temps, son œuvre*, Paris 1922, p.333.

Index

First published 2017 by order of the Tate Trustees
by Tate Publishing, a division of Tate Enterprises Ltd,
Millbank, London SW1P 4RG
www.tate.org.uk/publishing

© Tate Enterprises Ltd 2017

All rights reserved. No part of this book may be
reprinted or reproduced or utilised in any form or
by any electronic, mechanical or other means now
known or hereafter invented, including photocopying
and recording, or in any information storage or
retrieval system, without permission in writing
from the publishers or a licence from the Copyright
Licensing Agency Ltd, www.cla.co.uk

A catalogue record for this book is available from the
British Library
ISBN 978-1-84976-529-9

Distributed in the United States and Canada by
ABRAMS, New York

Library of Congress Control Number applied for

Designed by Anne Odling Smee, O-SB Design
Layout by Caroline Johnston
Colour reproduction by DL Imaging Ltd, London
Printed by Graphicorn Srl, Italy

Frontispiece: Camille Pissarro, *Hoar Frost* 1873 (detail,
see fig.39)
Cover: Claude Monet, *The Thames below Westminster*
1871 (detail, see fig.32)

Measurements of artworks are given in centimetres,
height before width.

Credits

References are to figure numbers.

Photo credits

akg-images 47

Amgueddfa Genedlaethol Cymru / National
Museum of Wales 31

The Art Institute of Chicago, IL, USA / Mr and
Mrs Lewis Larned Coburn Memorial Collection /
Bridgeman Images 52

© Ashmolean Museum, University of Oxford 2

© Bibliothèque nationale de France 4, 5

© Brooklyn Museum 59

© Chrysler Museum of Art / Ed Pollard 9

© CSG CIC Glasgow Museums Collection /
Bridgeman Images 41

Dallas Museum of Art/Brad Flowers 1

Photo Archives Durand-Ruel © Durand-Ruel &
Cie., rights reserved 8

© The Fitzwilliam Museum, Cambridge 35

Fondation Jean et Suzanne Planque, on deposit
at the Musée Granet, Aix-en-Provence (inv. FJSP-
998-116) © photo Luc Chessex 57

Photography by Erik Gould, courtesy of the
Museum of Art, Rhode Island School of Design,
Providence 33

Photo The J. Paul Getty Museum, Los Angeles 27

From the Collection of Professor Mark Kaufman
55

Kunstmuseen Krefeld, Photo: Volker Döhne 60

Kunstmuseum Winterthur, Donated by Dr
Herbert und Charlotte Wolfer-de Armas, 1973 ©
Schweizerisches Institut für Kunstwissenschaft,
Zürich, Lutz Hartmann 192 bottom 43

© Lyon MBA – Photo Alain Basset 49, 58

© Metropolitan Museum of Art, New York 13, 14

Musée Marmottan Monet, Paris, France /
Bridgeman Images 6, 34

Photo (C) Musée d'Orsay, Dist. RMN-Grand Palais
/ Patrice Schmidt 7, 46

Museum of Fine Arts, Boston. The Hayden
Collection-Charles Henry Hayden Fund.
Photograph © 2017 Museum of Fine Arts, Boston
45

Museum of Fine Arts, Boston. 1931 Purchase
Fund. Photograph © 2017 Museum of Fine Arts,
Boston 36

© The National Gallery, London cover 10, 11, 17,
22, 23, 25, 30, 32, 56

Nationalmuseum, Stockholm 26

© National Museums Scotland 42

The Nelson Atkins Museum of Art, Kansas City.
Photo: Jamison Miller 40

Private Collection / Archives Charmet / Bridgeman
Images 3

Private collection / Bridgeman Images 28

Private collection, USA 54

© RMN – Grand Palais / Michel Urtado 37; (musée
de l'Orangerie) / Michel Urtado 61; (musée
d'Orsay) / Gérard Blot 16; / Hervé Lewandowski
12, 18, 19, 24, 38, 48, 53; / Tony Querrec 39

The Samuel Courtauld Trust, The Courtauld
Gallery, London 29, 44

© The Trustees of the British Museum 15

Tate. Bequeathed by Lucien Pissarro, the artist's
son 1944. Photograph © Tate, 2017 20

Tate. Presented by the Art Fund. Photograph ©
Tate, 2017 21

Tate. Presented by Samuel Courtauld. Photograph
© Tate, 2017 / Lucy Dawkins 50

Tate. Bequeathed by Mrs A.F. Kessler 1983.
Photograph © Tate, 2017 / Mark Heathcote and
Samuel Cole 51